BIOGRAPHIC
VAN GOGH

BIOGRAPHIC
VAN GOGH

SOPHIE COLLINS

AMMONITE
PRESS

First published 2016 by
Ammonite Press
an imprint of Guild of Master Craftsman Publications Ltd
Castle Place, 166 High Street, Lewes, East Sussex, BN7 1XU,
United Kingdom

Created for Ammonite Press by Biographic Books Ltd

ISBN 978 1 78145 275 2

Publisher: Jason Hook
Concept Design: Matt Carr
Design & Illustration: Matt Carr & Robin Shields
Editor: Jamie Pumfrey
Consultant Editor: Dr Diana Newall
Project Editor: Rob Yarham
Picture Research: Hedda Roennevig

Colour reproduction by GMC Reprographics
Printed and bound in China

CONTENTS

ICONOGRAPHIC

WHEN WE CAN RECOGNIZE AN ARTIST BY
A SET OF ICONS, WE CAN ALSO RECOGNIZE
HOW COMPLETELY THAT ARTIST AND THEIR
WORK HAVE ENTERED OUR CULTURE
AND OUR CONSCIOUSNESS.

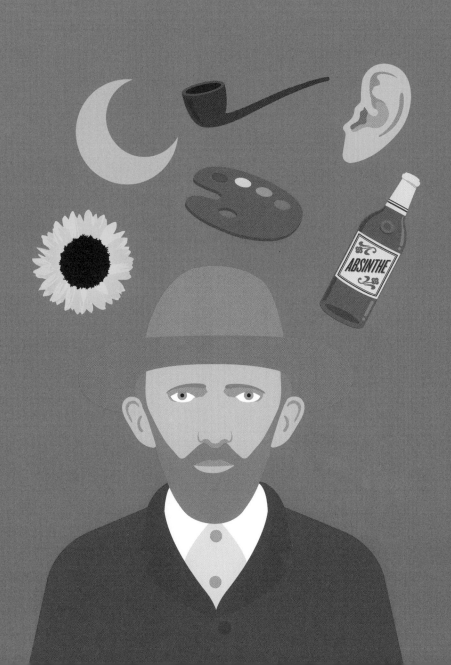

INTRODUCTION

Most people know at least three things about Vincent van Gogh: that he cut off his own ear, that he was mad – ultimately committing suicide – and that he painted *Sunflowers*. And while all three things are more or less true, they leave an unsatisfying impression of the man and his work. With the benefit of distance, a closer look at his short life – he died at only 37 – sees the personal drama recede and the paintings move into the foreground. Perhaps the question becomes: how on earth did he do what he did, without money, with only sporadic support, and while struggling with frequent attacks of debilitating illness?

Van Gogh tried to wrangle his personality into a variety of roles before he turned to art. As a teenager he went to work in his uncle's art dealership, but his manner was too blunt to appeal to customers who sought assurances of their fine taste. After his final dismissal, he turned to religion: perhaps he could put his passion into preaching? It turned out to be a false start – Vincent certainly didn't lack the conviction to become a minister (and, as a clergyman's son himself, he knew quite a lot about it), but he couldn't manage the formal study required to make the grade.

"I CONSIDER MYSELF TO BE AT THE BEGINNING OF THE BEGINNING OF MAKING SOMETHING SERIOUS."

When, at the age of 27, Van Gogh finally threw himself into art, he worked doggedly and conscientiously for some time before he broke through. The glorious flowering of his last few years was the reward for a life lived with almost constant conflict and huge depths of depression and disappointment.

Although he didn't have much luck in some ways, Van Gogh was very fortunate indeed in his brother, and even more so in his sister-in-law. Theo had been Vincent's prop and support; he had offered sensible counsel, and as much money as he could afford, to help his brother realize his vision as an artist. Not only that, but after the deaths of both brothers, Theo's wife, Johanna, did everything that she could to further his posthumous reputation and enable his work to gain the recognition that it deserved. Nor did it take very long. The art world was starting to see what perspicacious contemporaries such as Gauguin had already spotted: that here was a genuinely fresh and unique vision that, like all the best art, enabled them to see the familiar in a new and revealing light.

"IDEAS FOR WORK ARE COMING TO ME IN ABUNDANCE. I'M GOING LIKE A PAINTING-LOCOMOTIVE."

"THE UGLIER, OLDER, MEANER, ILLER, POORER I GET, THE MORE I WISH TO TAKE MY REVENGE BY DOING BRILLIANT COLOUR, WELL ARRANGED, RESPLENDENT."

Van Gogh did not live to collect the reward for his hard work. Today, with his work reproduced on everything from aprons to biscuit tins, it can be hard to 'see' Van Gogh's paintings as if for the first time. But it's worth reading round his life and times a little to add some knowledge and perspective before taking another look. He worked in earnest for only a little over a decade, and what he created was extraordinary in both quantity and quality: over 2000 works, plus a mass of letters that express the thinking behind the work with a clarity that few other artists have achieved.

"NORMALITY IS A PAVED ROAD: IT'S COMFORTABLE TO WALK, BUT NO FLOWERS GROW ON IT."

Vincent van Gogh's art has engaged and absorbed millions of people in the decades since his death. And, given his extraordinary achievement, perhaps, as the art historian Julian Bell has written, '...it is not our business to call him mad'.

VINCENT VAN GOGH

01
LIFE

"WHAT WOULD LIFE BE IF WE HAD NO COURAGE TO ATTEMPT ANYTHING?"

—Van Gogh in a letter to his brother Theo,
from The Hague, 29 December 1881

VINCENT WILLEM VAN GOGH

was born on 30 March 1853 in Groot-Zundert, on the border between the Netherlands and Belgium

Vincent was born in the parsonage on the Markt, or market square, of the small town. He was the son of Theodorus van Gogh, minister at Zundert's Dutch Reformed Church (automatically giving him a certain social standing in the parochial world of provincial 19th-century Brabant) and Anna Cornelia Carbentus, the daughter of a bookbinder who had artistic leanings herself. His Christian name was traditional within the family, with at least one Vincent in every generation.

◀ Also born in North Brabant: **Hieronymus Bosch** (1450–1516)

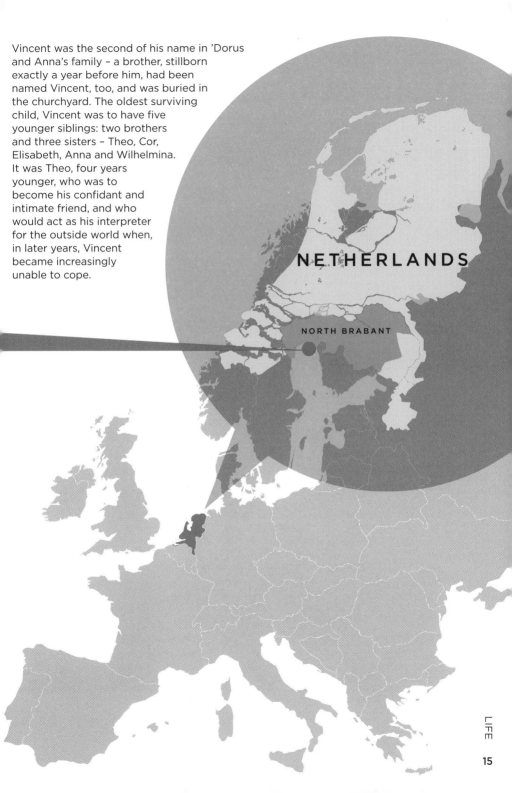

Vincent was the second of his name in 'Dorus and Anna's family – a brother, stillborn exactly a year before him, had been named Vincent, too, and was buried in the churchyard. The oldest surviving child, Vincent was to have five younger siblings: two brothers and three sisters – Theo, Cor, Elisabeth, Anna and Wilhelmina. It was Theo, four years younger, who was to become his confidant and intimate friend, and who would act as his interpreter for the outside world when, in later years, Vincent became increasingly unable to cope.

NETHERLANDS

NORTH BRABANT

JAN	FEB	MAR	APR	MAY	JUN

SAN FRANCISCO

The clothing company Levi Strauss & Co, manufacturers of hardwearing work clothes, is founded in San Francisco, USA.

NEW YORK

The Otis elevator company is founded in Yonkers, New York, USA.

NY STATE

The first potato chips go on sale in New York State, USA.

THE WORLD IN
1853

PARIS

Georges-Eugène Haussmann is appointed to oversee the redesign of the city of Paris.

The world Vincent was born into was small. Not only was Zundert on the border between Belgium and the Netherlands, but the whole province of Brabant (originally a single Catholic entity) had been summarily split. It had been divided between the two countries in 1839, just 14 years before his birth. The uneasy truce that resulted turned Theodorus van Gogh's small congregation into a little island of Protestantism surrounded by Catholic believers. This may have been one reason why the Van Gogh family tended towards seeing a close family circle, a respectable social position and a strict work ethic as the keys to a happy life. Out in the world, though, plenty was happening, both in the Netherlands and further afield.

VENICE

Verdi's daringly modern opera *La Traviata* is performed for the first time in Venice.

JUL AUG SEP OCT NOV DEC

NETHERLANDS

After two centuries, Catholic bishops return to the Netherlands under new freedom-of-association laws.

MAASTRICHT

The railroad linking Maastricht with Aachen in the Netherlands opens.

URAGA

Admiral Perry arrives in Japan and requests trade relations for the US with 'the closed kingdom'.

LONDON

In England, the naturalist Charles Darwin is awarded the Royal Society's Gold Medal in recognition of his work on the voyage of the *Beagle*.

BOMBAY

The first passenger railway in India opens, running between Bombay and Thane in the state of Maharashtra.

Family Tree Diagram

Willem Carbentus (1792–1845)

Anna Cornelia van der Gaag (1792–1855)

Willemina Catharina Gerardina Carbentus (1816–1904)

Clara Adriana Carbentus (1817–1866)

Arie Carbentus (1826–1875)

Johannes Rutgerus Carbentus (1827–1875)

Cornelia Carbentus (1829–1913)

Anna Cornelia Carbentus (1819–1907)

Theodorus van Gogh (1822–1885)

VINCENT'S FAMILY TREE

Van Gogh's mother came from a comparatively cosmopolitan background in The Hague. When she reached the advanced age of 30 without having married (a disaster in the mid-19th century), her sister Cornelia, 10 years younger, proposed that Anna consider the unmarried brother of her own fiancé. So, while Cornelia married her own Vincent van Gogh (who owned a successful art dealership in the Hague, and was to be known as Uncle Cent to his nieces and nephews), Anna became betrothed to his younger brother, Theodorus, who had recently been appointed to the small Protestant church in dowdy Groot-Zundert. She had accepted his hesitant proposal with mixed feelings, but marriage and motherhood were essentials and she married 'Dorus on 21 May 1851.

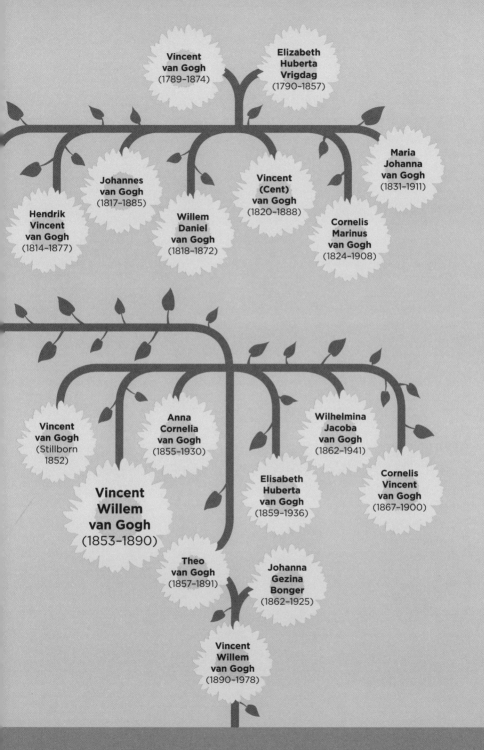

LIFE BEFORE ART

1853
Vincent van Gogh is born on 30 March.

1855
Gustave Courbet paints *The Artist's Studio* to show at an exhibition in Paris, Le Réalisme.

1861
Vincent attends the village school in Zundert. His parents worry that it is 'coarsening' their son, and he is withdrawn to be taught at home.

1875
Impressionists including Renoir and Monet (below) arrange an auction of their controversial works at the Hotel Drouet. The art causes uproar, and the police have to be called.

1874
The first Impressionist exhibition is held in Paris. Monet, Renoir, Cézanne, Degas, Pissarro, Morrisot and Sisley all show works. Monet coins the name 'Impressionism'.

1873
Transferred to the London offices of Goupil & Cie. Develops an affection for Eugénie Loyer, his landlady's daughter.

1876
Dismissed from Goupil & Cie. Returns to England and works as a teacher in Ramsgate. Teaches Sunday School at an evangelical church in Isleworth.

1877
Briefly joins bookseller Blussé & Van Braam, in Dordrecht, as a sales clerk, before moving to Amsterdam to study for entrance exams to theological college.

The story of Vincent's first 26 years is one of constant new beginnings, each followed by failure, accompanied by boundless self-reproach, before another new beginning presents itself. His family, focused on his need to earn his living and to present a respectable face to the world, never understood the ways in which he seemed to constantly self-sabotage. As Van Gogh tried and failed both as an art dealer's clerk and as a preacher, the world of art was moving towards the revolutionary approach of Impressionism.

1863

Edouard Manet finishes *Le Déjeuner sur l'Herbe* and *Olympia*, both featuring unconventional nudes. He causes a scandal when they are shown at the Paris Salon.

1864

Studies at Protestant boarding school in Zevenbergen. The youngest pupil, he is isolated and lonely, constantly pleading to come home.

1866

Van Gogh's parents move him to the Rijschool Willem II in Tilburg. He is again bitterly unhappy, and walks out two years later.

1872

Begins lifelong correspondence with his brother Theo. Forms a fixation on Caroline Haanebeek, who is already engaged to his cousin; begins visiting brothels.

1871

The art dealer Paul Durand-Ruel buys 23 paintings by Edouard Manet for 35,000 francs – a sign of the growing interest in the 'new movement', not yet named.

1869

Aged 16, travels to The Hague to join international art dealers Goupil & Cie as a clerk. Has the opportunity to study both traditional and modern Dutch art.

1878

Gives up studies in theology. Moves to the Borinage, a mining area in Belgium, and practises as an evangelical preacher.

1879

At the Fourth Impressionist Exhibition, Paul Gauguin's work is included for the first time.

Alarmed by his declining physical state, Van Gogh's parents attempt, unsuccessfully, to have him committed to an asylum. Having spent an increasing amount of time drawing over the last two years, and written extensively to Theo about modern developments in art, in the summer of 1879 Vincent determines to become an artist.

 VINCENT'S WORLD **THE ART WORLD**

GIRL TROUBLE

Van Gogh's lack of romantic success has gone down in history. The mores of his time, combined with his strictly moral upbringing, meant that he divided women into two groups: respectable ladies and sexually enticing whores. Like many of his contemporaries, he visited brothels frequently from his teens – and made little secret of it – to the horror of his family back at the vicarage. It didn't lessen his longing for an accepted relationship and married love, though, and although his attempts invariably ended in tears, he kept trying.

1872 CAROLINE HAANEBEEK 👫

Already engaged when Vincent began to take a serious interest in her. Undeterred, he pursued her with romantic gestures even after her marriage.

1873 EUGÉNIE LOYER 👫

The daughter of his London landlady, it turned out that Eugénie was already secretly engaged to someone else.

1881 KEE VOS-STRICKER 👫

Van Gogh's widowed cousin. He proposed repeatedly while they were both staying with his parents in Etten, but she roundly rejected him.

1884 MARGOT BEGEMANN 👫

A neighbour of Van Gogh's parents, who fell in love with him and ultimately took poison when he did not reciprocate. She recovered, but the affair was over.

1882-1883 SIEN HOORNIK 👫

Seamstress, washerwoman and prostitute who was first Van Gogh's model, then, with her young daughter, shared his house for a year. At one point he proposed marriage, but the relationship foundered a few months later.

1886-1887 AGOSTINA SEGATORI 👫

Neapolitan owner of Le Tambourin café in Paris. She hung his works on the café walls, found him street girls (many of whom also served as his models) and posed for him herself. The two are believed to have had a relationship, but Segatori's violent underworld connections frightened Van Gogh off.

KEY

 Respectable

 In love

 Promiscuous

 Not in love

"GRANT THAT ONE DAY MRS VAN GOGH SITS BEFORE US IN THE CARRIAGE. AMEN."
—Letter to Theo, 1877

Caroline
Haanebeek

Eugénie
Loyer

Kee
Vos-Stricker

Margot
Begemann

Sien
Hoornik

Agostina
Segatori

"IF YOU WAKE UP IN THE MORNING AND YOU'RE NOT ALONE... IT MAKES THE WORLD SO MUCH MORE AGREEABLE..."
—Letter to Theo, 1881

LIFE

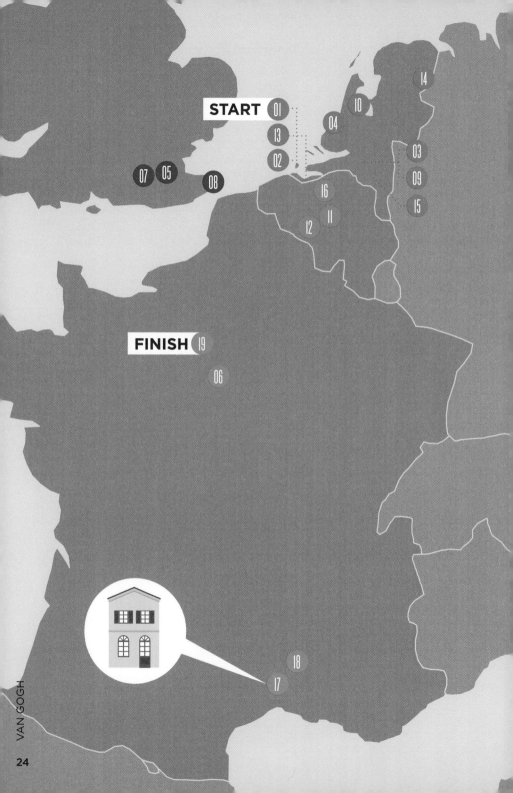

START 01
13
02
04
10
14
03
09
15
16
11
12
08
07 05

FINISH 19
06

18
17

VAN GOGH

24

WANDERING IN EUROPE

Over his short life, Van Gogh was perpetually on the move. As one location disappointed him, he was constantly yearning after the next adventure – the place in which he imagined he would find peace. He lived in over 20 different towns and cities in search of a place that might meet his idealized vision of home. The closest he came was probably the Yellow House in Arles.

THE NETHERLANDS

01 Zundert
1853–63

02 Zevenbergen
1864–6

03 Tilburg
1866–8

04 The Hague
1869–73, 1881–3

09 Dordrecht
1877

10 Amsterdam
1877–8

13 Etten
1881

14 Drenthe
1883

15 Nuenen
1883–5

BELGIUM

11 Brussels
1878, 1880–81

12 Borinage
1879–80

16 Antwerp
1885–6

ENGLAND

5 London
1873–5

7 Isleworth
1876

8 Ramsgate
1876

FRANCE

6 Paris
1874–5, 1876, 1886–8

17 Arles
1888–9

18 Saint-Rémy-de-Provence
1889–90

19 Auvers-sur-Oise
1890

WHAT WAS WRONG WITH VAN GOGH?

Van Gogh would spend his life under the shadow of what, at the time, most people would simply have called insanity. Although he was just three years older than Sigmund Freud, it was long before psychoanalysis came into being, and antipsychotic drugs did not yet exist in any effective form.

Ricocheting from crisis to crisis, Vincent was lucky enough to encounter several sympathetic doctors. His attempts to self-medicate – with copious quantities of absinthe, periodic starvation, and a taste for white lead paint – were unlikely to help. But exactly what was wrong with Vincent? Shortly after his death a debate began that has continued ever since, diagnosing everything from syphilis and manic depression to porphyria...

HIGHLY LIKELY

LIKELY

UNLIKELY

HIGHLY UNLIKELY

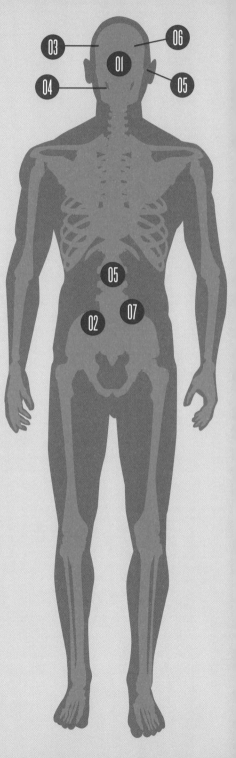

01 💉 EPILEPSY

+ Diagnosed in both Saint-Rémy and Arles during his lifetime
+ Treated effectively with bromide (which works on some forms, but not others)
- Seizures as described don't match either grand mal or temporal lobe epilepsy

02 💉 LEAD POISONING

+ Van Gogh was known to eat his paint, much of which contained toxic pigments that could have caused both delusions and gastric problems
- It's likely that his habit would have been a contributing factor to existing problems, rather than causing crises in itself

03 💉 PORPHYRIA

+ Characterized by strong delusions and periods of depression
- Both rare and hereditary, not evident in his parents' other descendents

04 💉 SYPHILIS

+ His brother Theo suffered from syphilis, and it has long been held that Vincent was also syphilitic
+ Causes depression and delusions in its later stages
- Unsupported by Van Gogh's (admittedly incomplete) medical records
- Few doctors in the later 19th century would fail to consider it, or to recognize it

05 💉 MÉNIÈRE'S DISEASE

+ This affliction of the inner ear causes poor balance, vertigo and attacks of sickness
+ Van Gogh's cutting off of his own ear might be seen as an attempt to relieve the pain
- Van Gogh's health problems had much wider symptoms
- Ménière's disease would not have caused the symptoms on its own

06 💉 BIPOLAR DISORDER

+ Periods of deep depression and apathy alternating with 'highs' (stretches of manic productivity and optimism) are characteristic of people with bipolar disorder

07 💉 ABSINTHE POISONING

+ This mixture of a high alcohol content, wormwood and copper – used to create its bright green colour – could cause faulty memory, hallucinations and digestive problems
+ Van Gogh suffered from all three symptoms

➕ DIAGNOSIS

It seems most likely from his complex symptoms that Van Gogh suffered from a mix of conditions, certainly aggravated by his lifestyle and sometimes by his treatment. There is evidence of a seam of depression in the family. Of his siblings, Theo certainly suffered some of the same miseries; his sister Wil spent her last years in an asylum; and there is a suggestion his youngest brother Cor committed suicide.

LIFE AS AN ARTIST

Pursuing his art, Van Gogh fought with everyone who could help him. He could not admit he was at fault, and repeatedly turned on even his close friends. In the mid-1880s, he emerged as a mature talent. For the next five years, his art was a formidable, unstoppable force... even when its maker was at breaking point.

PERSONAL

WORK

1885

Father dies suddenly; moves to Antwerp.

Completes *The Potato Eaters*, his first important oil painting.

1884

Reconciles with parents; relationship with Margot Begemann, 13 years his senior, ends when her parents forbid her to marry him and send her away.

Paints and draws constantly; first signs of his characteristic style begin to emerge; expresses contempt for Impressionists.

1880

Moves to Brussels; parents become reluctant to support him.

Befriends Dutch painter Anthon van Rappard; takes anatomy and life drawing classes.

1882

Moves pregnant model and prostitute, Sien Hoornik, and her small daughter into house; contracts gonorrhoea; admitted to hospital; Sien gives birth, talk of marriage; separates from Sien; visits parents in Nuenen.

Rents studio; starts to draw from models; quarrels with Mauve; his Uncle Cor commissions a dozen street scenes; they fall out over money; creates first watercolours; studies lithography.

1881

Returns home to parents; proposes marriage to his widowed cousin, Kee Vos-Stricker, who refuses him; quarrels disastrously with parents.

Takes watercolour lessons with another cousin, Anton Mauve (a successful member of the conventional, popular Hague School art movement).

1886

Moves to Paris, moves in with Theo.

Attends classes at Antwerp Academy; meets French artists including Toulouse-Lautrec; admires work of the Impressionists.

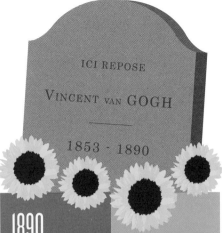

ICI REPOSE

Vincent van GOGH

1853 - 1890

1887

Paints with Paul Signac on banks of Seine; organizes *Impressionistes du Petit Boulevard* exhibition, showing his work alongside Toulouse-Lautrec, (right) and meeting Gauguin, Seurat and Pissarro.

1890

Suffers attack lasting two months; pronounced 'cured'; travels to Auvers under care of Dr Paul Gachet; rents room at Ravoux Inn, suffers gunshot wound to stomach; dies at Auvers; buried next day in town's new cemetery.

Shows six works at annual exhibition of *Les Vingtistes*; favourably reviewed by the highly regarded young critic Albert Aurier; paints constantly and quickly until death.

1888

Moves to Arles; moves into Yellow House; invites Gauguin; relationship with Gauguin sours; after furious confrontation, Gauguin leaves for Paris; mutilates ear; meets Dr Félix Rey in Arles hospital.

Frantically productive; paints orchards in bloom; paints portraits and pictures of southern harvest; paints sunflowers; works with Gauguin.

1889

In and out of hospital; admits himself to mental institution Saint-Paul de Mausole in Saint-Rémy; suffers seizures.

Suffers seizure while painting outdoors, becoming ill and unable to work; returns to work; suffers another seizure.

A CURIOUS END

"I WOUNDED MYSELF."
—Van Gogh's explanation to Gustave Ravoux, his landlord

"THE SADNESS WILL LAST FOREVER."
—Van Gogh's dying words, to his brother Theo

On 27 July 1890 Van Gogh lunched at the Ravoux Inn, where he was boarding, then went out, as he had over the last two or three weeks, to paint. His fellow-lunchers saw nothing unusual in his mood. Hours later, his landlord heard groans from his room. Vincent showed him a gunshot wound under his ribs, which he would die from two days later. This has become one of the most famous suicides in art history.

Van Gogh was painting constantly and had (for him!) been cheerful.

There was no suicide note (and Van Gogh was an almost compulsive communicator).

The gunshot wound was in an odd place for a suicide.

In the 1960s a rusted gun was found close to where Van Gogh had been painting.

Scholars have presented evidence suggesting that Vincent was in fact murdered by local youths: his cheerful mood, the lack of a suicide note, the position of the wound. The discovery of the 'suicide weapon' undermines this conspiracy theory.

VINCENT
VAN GOGH

02
WORLD

"I AM NOT AN ADVENTURER BY CHOICE BUT BY FATE... AND FEELING NOWHERE SO MUCH MYSELF A STRANGER AS IN MY FAMILY AND COUNTRY."

—Van Gogh in a letter to the English painter Horace Livens, October 1886

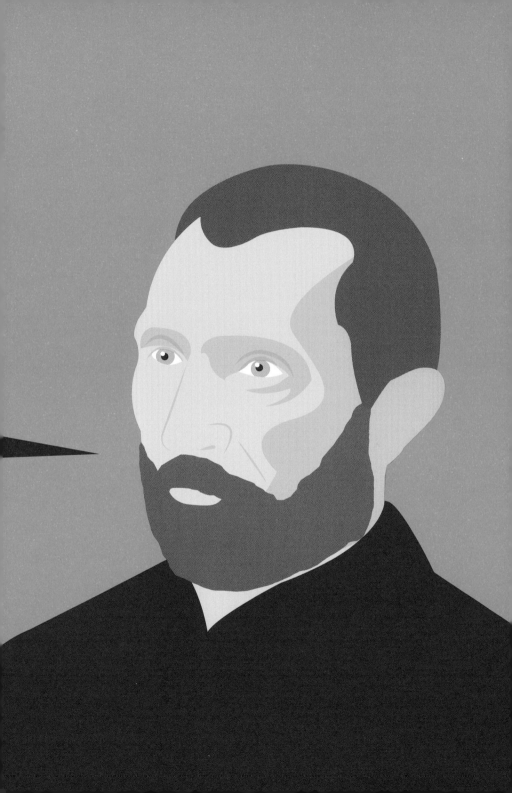

DEAR THEO...

Van Gogh was almost as prolific a letter-writer as he was a painter. Over 800 letters survive (mostly those to his brother Theo, which were carefully preserved by his widow after Theo's death), and they include a mass of drawings as well as thousands of words. They give plenty of insights into his mental state at any given time: famously incontinent emotionally, he spared his correspondents neither his highs nor lows.

DIVERSE SUBJECTS INCLUDING, BUT NOT CONFINED TO...

COMMERCIAL PROSPECTS

He enquires after a professional discount:

"...wouldn't it be possible to obtain paint, panels, brushes, etc at discount prices? I am having to pay the retail price at the moment.... One doesn't paint well by using a lot of paint... but sometimes one must not spare the tube...."

—To Theo van Gogh, September 1882

FASHION ADVICE

Vincent advises Theo that he walks from his lodgings to his office in Covent Garden in his top hat:

"...you cannot be in London without one."

WORK IN PROGRESS

*"This time, it's simply my bedroom. Only here everything depends on the colour...
The walls are pale violet. The floor is red tiles.
The wood of the bed and the chairs is the yellow of fresh butter, the sheet and the pillows very light lime green.
The blanket scarlet.
The window green...
And that's all – nothing of any consequence in this shuttered room."*

—To Theo van Gogh, October 1888

Van Gogh's last letter to his brother was never posted. Theo found it in the pocket of his jacket after his death.

874
surviving letters

850,000
words

651
letters to Theo van Gogh

22
letters to Wilhelmina van Gogh

201
to artists, benefactors and romantic prospects

LA POSTE

A letter-writer as prolific as Van Gogh would have found it difficult without an efficient postal system to carry his effusions quickly to their destinations. Luckily, the French postal system was equal to the job in Paris and, after he moved, in Arles, then in Auvers-sur-Oise. In Arles, Van Gogh became friendly with – and painted – Joseph Roulin, the postman.

IN THE LATE 1880S

● **Number of post offices in Paris: 100+**

○ **Number of letter boxes at each collection point: 4**
 - Paris
 - French *départements*
 - foreign mail
 - printed papers (special rate)

● **Number of days it took to deliver a letter from the provinces (Auvers or even Arles) to Paris, and vice versa: 1**

● **Number of days it took to deliver a letter from the Netherlands to Paris: 1**

● **Sunday and holiday collections: 5**

● **Workday collections: 8**

● **Number of days it took to deliver shipments (of paints or canvas) to Arles from Paris: 2–4**

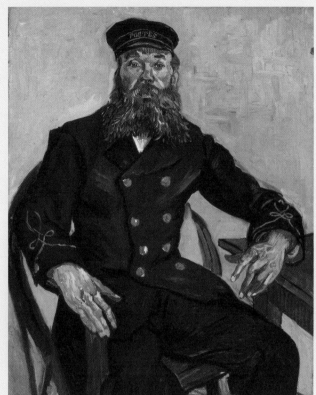

▲ *Postman Joseph Roulin*
Oil on canvas, 1888
32 x 26 inches (81 x 65 cm)

"I DON'T KNOW IF I CAN CONVEY THE POSTMAN AS I FEEL HIM... UNFORTUNATELY HE CANNOT POSE, AND A PAINTING DEMANDS AN INTELLIGENT MODEL."

—Van Gogh, 1888

VAN GOGH'S CONNECTIONS

Gustave Ravoux, landlord (also model)

Dr Gachet, physician

Lovers

Supporters

Friends

Family

Paul Signac, artist

John Peter Russell, artist

Henri de Toulouse-Lautrec, artist

Emile Bernard, artist

Louis Anquetin, artist

FRANCE

Madame Ginoux, landlady

Joseph Roulin, postman (also model)

Dr Peyron, physician

Anthon von Rappard, artist

Dorus van Gogh, father

Anna van Gogh, mother

Wilhelmina van Gogh, sister

Theo van Gogh, brother

NETHERLANDS

Agostina Segatori, café owner (also model)

Sien Hoornik, prostitute (also model)

AUVERS-SUR-OISE

PARIS

Anton Mauve, painter and patron

Paul Gauguin, artist

Julien 'Père' Tanguy, paintshop proprietor (also model)

Fernand Cormon, painter and patron

Albert Aurier, art critic

ARLES AND SAINT-RÉMY

VINCENT VAN GOGH 1853-1890

Van Gogh worshipped the ability of his fellow painter Paul Gauguin, and their difficult friendship outlasted even the anguish of the quarrel that caused Vincent to cut off his ear. But how do their lives measure up? Neither enjoyed much success during his lifetime, and each suffered from bouts of extreme ill health, although Van Gogh probably had it worse than Gauguin. Some key statistics show that there are as many points of similarity as there are differences.

$70m x 5

Between 1987–1998, five paintings by Van Gogh each exceeded prices of $70 million dollars (inflation adjusted), including a *Portrait of Dr Gachet*, one of his *Sunflowers* sequences and *Irises*.

FAME
Acquired a following and a reputation within 20 years of his death. Over 120 years later, he is one of the artists most familiar to a global audience outside the art gallery.

LOVE
Never married, although he conducted a liaison with Sien Hoornik, a prostitute, in 1882–3. Sporadic attractions to 'respectable' women tended towards idealism and were unreciprocated, causing him great pain.

HEALTH
Suffered constant attacks of illness and depression from his late teens, possibly as a result of bipolar disorder. Suspected of suffering from syphilis, but this seems unlikely.

PATRONS
Championed during his life and after his death by his brother Theo and later by Theo's widow Johanna Bonger.

LIVED **37** YEARS

1848-1903 PAUL GAUGUIN

$300m

When Will You Marry?, one of his Tahitian paintings, sold for $300 million in 2015, breaking all previous records.

FAME
Recognized as a master within 20 years of his death, and strongly influenced many other painters, including the young Picasso.

LOVE
Married, with five children by his first wife, two of whom died before him. Later had two more children with his Tahitian *vahine* (wife), his son surviving him.

HEALTH
Believed to have suffered from (and ultimately died of) syphilis.

PATRONS
Championed during his life and after his death by the art dealer Ambroise Vollard.

LIVED
54
YEARS

LA FÉE VERTE

Absinthe – *la fée verte* (green fairy) in romantic slang – was a notorious part of the artistic life of the 19th century. Illustrated papers showed lurid pictures of addicts in the grip of delirium, while dissolute drinkers were constantly warned of the dangers of indulging. Van Gogh was a heavy imbiber, but so were most of his artistic friends – it was endemic. By 1915, it was banned in many European countries. But why was this drink, in particular, and in an era when alcoholism was far from uncommon, deemed to be so damaging?

WHAT'S IN IT?

Alcohol
......................

In the 1880s, up to...

75%

Herbs
......................

Anise

......................

Fennel

......................

Wormwood, *Artemisia absinthium* (which contains thujone, a chemical that can cause seizures when consumed in large quantities)

ABSINTHE

WHO DRANK IT?

Van Gogh and Gauguin were both heavy topers, although absinthe was far from their only alcohol. Amedeo Modigliani and Toulouse-Lautrec also drank it to excess. But plenty of others drank it and remained well – Pablo Picasso (right) swore by a daily glass throughout his youth.

Colouring

In the 19th century, the green colouring was often boosted by adding toxic quantities of copper.

▲ *The Night Café*
Oil on canvas, 1888
28 x 36 inches (72 x 92 cm)

WHAT CAUSED VAN GOGH TO SEE YELLOW?

Vincent's strong and personal use of yellows – sometimes to almost lurid effect, as in *The Night Café* – has been attributed to a number of causes. An excess of thujone can affect the vision, so absinthe may have been a contributing factor, but digitalis, a drug which he was regularly prescribed, can also cause patients to 'see yellow'. The peculiarity of his palette may have been chemical, entirely personal... or a mixture of the two.

THE YELLOW HOUSE

Through the mid-1880s Van Gogh dreamed of a studio in a warm climate where he could paint with like-minded companions. When he moved to Arles in May 1888, he rented the east wing – four rooms – of the Yellow House, on the Place Lamartine. At first he couldn't afford to furnish them, but on 1 September he moved in. The dream didn't last. Although Paul Gauguin arrived in late October and the two worked together for nine weeks, their relationship became increasingly strained and culminated in the row after which Van Gogh cut off his ear. He left the Yellow House in April 1889 after local people, alarmed by his eccentric, violent behaviour, petitioned the mayor for him to be confined.

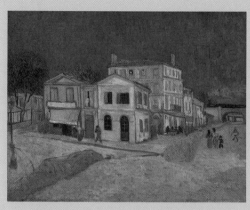

▲ *The Yellow House (The Street)*
Oil on canvas, 1888
28 x 36 inches (72 x 91 cm)

Paintings Van Gogh made specifically to decorate the Yellow House:

4 *Sunflower* paintings...

The Night Café, *The Tarascon Stagecoach*, *Starry Night over the Rhone*, and *The Trinquetaille Bridge.*

LOCATION

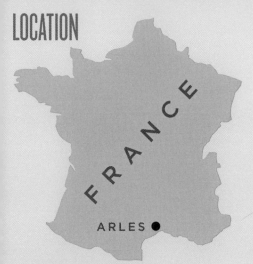

F R A N C E

ARLES ●

RENT

15 francs per month

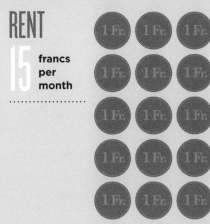

1 Fr. 1 Fr. 1 Fr.
1 Fr. 1 Fr. 1 Fr.
1 Fr. 1 Fr. 1 Fr.
1 Fr. 1 Fr. 1 Fr.
1 Fr. 1 Fr. 1 Fr.

ROOMS

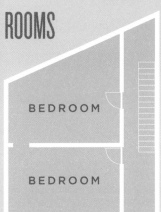

BEDROOM

BEDROOM

STUDIO

KITCHEN

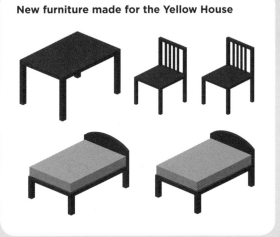

New furniture made for the Yellow House

30

The number of names on the petition demanding that Van Gogh be moved to an asylum to undergo treatment:

WORLD

45

VAN GOGH'S EAR

Everyone knows the story: after a row in which Gauguin had declared he was going to leave the Yellow House, Van Gogh cut off his left ear in a fit of mania and handed it to a cleaning girl he had befriended in Arles. For years, biographers disagreed as to how much of the ear he severed, and whether or not large quantities of absinthe were involved. In 2016, a researcher identified a sketch by the young doctor, Félix Rey, who treated the artist, which solved the debate for good.

SELF-AMPUTATION IS SO RARE THAT IT IS KNOWN AS VAN GOGH SYNDROME IN MEDICAL TEXTBOOKS

23 DECEMBER 1888
THE YELLOW HOUSE,
2 PLACE LAMARTINE, ARLES

Van Gogh had received a letter giving the news of his brother Theo's engagement, which may have destabilized his state of mind and aggravated the incident.

Rey's sketch shows that Van Gogh's entire ear was severed, leaving only a tiny part of the lobe attached. The wound would have bled very heavily.

Van Gogh wrapped the ear in newspaper and carried it to a local *maison de tolérance* (a semi-legal brothel) where he left it for a girl called Gabrielle who worked as a cleaner there.

Van Gogh was back painting – including two self-portraits, with bandaged ear – by January 1889.

The story made the national press: it appeared in both the local Arles paper and *Le Petit Journal* in Paris.

When Gabrielle received it, she called the police, who went to the Yellow House, arrested Van Gogh and took him to the local hospital.

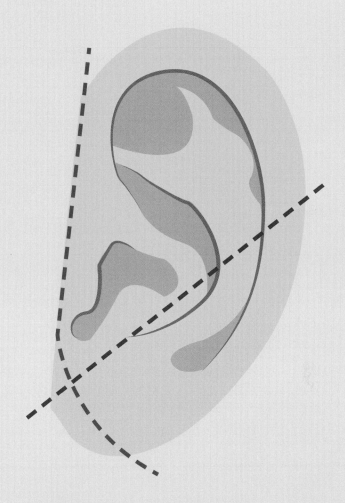

● Where he actually sliced his ear.

● Where art historians believed he sliced his ear.

THE ART OF FOOD

All his life, Van Gogh took a puritan attitude to food, sometimes eating a plain but wholesome diet, but starving himself at times of mental anguish. Meanwhile, many of his French contemporaries enjoyed a gourmet diet with the newly-sophisticated cuisine that was becoming fashionable in the 1880s.

1885
GIVERNY, FRANCE

Claude Monet was collecting recipes for his kitchen notebooks, including a traditional Provençal *bouillabaisse* from Paul Cézanne, and little bread rolls from Millet. These would be served with his own cook's concoctions – *sole à la Normande* and *tarte tatin*. Lunch was served punctually at 11.30am.

ANTWERP, BELGIUM

Vincent van Gogh was living on a spartan daily regime:

"What is keeping me going is my breakfast with the people where I live, and a cup of coffee and some bread in the crémerie in the evening. Supplemented, when I can, by a second cup of coffee."

—Letter to Theo, 28 December

VAN GOGH

48

VINCENT VAN GOGH

03
WORK

"HE IS [THE ONLY ONE] WHO PERCEIVES THE COLOURS OF THINGS WITH SUCH INTENSITY, WITH SUCH A METALLIC, GEM-LIKE QUALITY..."

—Albert Aurier, critic, in *Les Isolés: Vincent van Gogh*, a review of the first show of Van Gogh's work, *Mercure de France*, January 1890

WORK RATE

His worst enemy could not have accused Van Gogh of laziness. He worked seriously as an artist for a little over a decade, between late 1879 and his death on 29 July 1890, but he was staggeringly productive. Among an estimated 2,100 artworks, there were at least 860 oil paintings – some estimates take the total closer to 900. From a slow start in the early 1880s to a peak of activity in 1890, the totals are impressive. Most of his best-known works were painted in the last three years of his life, between bouts of debilitating illness.

NOTABLE WORKS

- 1885 *The Potato Eaters*
- 1887 *Self-portrait with a Straw Hat*
- 1888 *Sunflowers*
- 1889 *The Starry Night*
- 1890 *Portrait of Dr Gachet*

ABOUT THE NUMBERS

These numbers are approximate and only refer to Van Gogh's major paintings, not his smaller sketches and lesser works. It is actually very difficult to be precise about the number of paintings Vincent produced in each year because not all the works are dated, and there is disagreement about which ones belongs to which year.

1884
1885
1886
1887
1888
1889
1890

PAINT BY NUMBERS

Van Gogh was conscious of the cost of his materials, but he never skimped on what he needed, even when someone else was paying. He sent many large orders to the paint shops of Paris through his brother Theo. Père Tanguy, of whom he made three portraits, was one of his suppliers, even though Vincent complained that 'his paint is really a little worse than everyone else's', but he most frequently ordered from Tasset & L'Hôte at 31 Rue Fontaine Saint-Georges.

20
Silver White
large tubes

10
Zinc White
large tubes

15
Veronese Green
double tubes

13
Chrome Yellow
double tubes

10
Lemon Chrome
Yellow double tubes

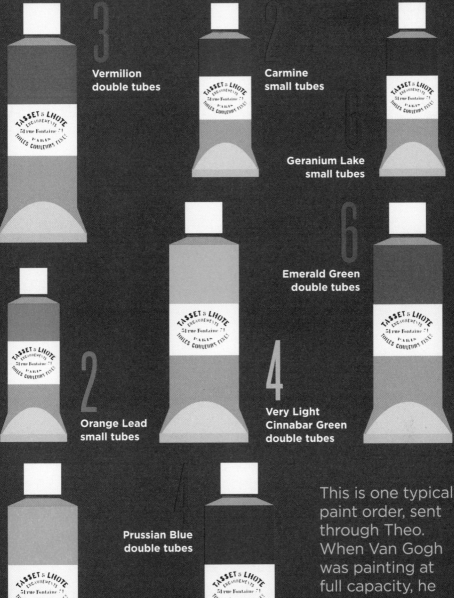

3
Vermilion
double tubes

2
Carmine
small tubes

6
Geranium Lake
small tubes

6
Emerald Green
double tubes

2
Orange Lead
small tubes

4
Very Light
Cinnabar Green
double tubes

4
Prussian Blue
double tubes

12
Ordinary Lake
double tubes

This is one typical paint order, sent through Theo. When Van Gogh was painting at full capacity, he might order this quantity of paint as often as every two weeks.

POISON PALETTE

The second half of the 19th century was a heyday for developments in artists' paint. Paint became available in tubes, making it easier for artists to work in the open air, and the chemists of the era created dozens of synthesized – and therefore cheaper – versions of colours that had previously only been available in their natural form. The downside was that many paints were highly poisonous in both their natural and their synthetic forms. Van Gogh was known to eat paint at times of

Naples Yellow
Originally known as Antimony yellow, derived from lead antimoniate. Dense and stable.

Vermilion
Orange-red, synthesized by reacting mercury with sulphur. Dense, holding colour.

Zinc Yellow
Synthetic zinc chromate, yellow with a greenish tinge, developed in about 1850. Semi-opaque.

Cochineal Lake
Van Gogh used tin-based synthetic cochineal a good deal. Vivid and dense, applied thickly it cracks badly over time.

Chrome Yellow
Natural pigment made from lead chromate, developed c. 1800. Inexpensive, offering bright, dense colour.

Chrome Orange
Natural pigment made from lead chromate, developed c. 1800. Inexpensive, with a bright, dense colour.

Geranium Lake
Made from eosine, a translucent and intense red, fashionable despite the instability of its colour. Used in many Arles works, including *Sunflowers*.

Vandyck Brown
Mix of natural clay, iron oxide, bitumen and humus. Used from around 1600, giving a clean, slightly translucent colour. Cracks and fades over time.

stress – the sweet aftertaste of lead-based preparations may have been comforting – and his palette offered an array of toxic snacking possibilities. Here are some of the colours he commonly used.

 Toxic

 Alizarin
A clear rosy red with a degree of translucency, but the synthesized version used by van Gogh, has a tendency to fade.

Viridian Green
Available from the mid-19th century. Similar in effect to Emerald green, but without the latter's very high toxicity.

Cobalt Blue
A pure, naturally occurring blue pigment used from the early 19th century. Expensive.

Emerald Green
One of the most brilliant greens and a favourite with Van Gogh. So toxic that it was also marketed as a poison for rats, under the name Paris Green.

Ultramarine
One of the earliest, truest blue pigments, made from lapis lazuli and extortionately costly. A synthetic, cheaper version was available by the 1830s.

Black
In its original form, made from burning organic materials such as wood to create black carbon.

Cerulean Blue
A clean, pure blue popular (as its name suggests) for painting skies. Similar to, but less rich and dense than, Cobalt.

Lead White/Zinc White
Van Gogh used both – the lead variant was toxic, the zinc one was slower-drying but was cheaper and harmless.

WORK

57

IN THE WINTER OF 1884–5 VAN GOGH PAINTED MORE THAN 40 STUDIES OF PEASANTS' HEADS

Inspired by his admiration for Barbizon artists, particularly Jean-François Millet, Van Gogh was dedicated to capturing rural scenes. While living with his parents in Nuenen, he made the studies that resulted in his famous painting, *The Potato Eaters.*

"THEY HAVE TILLED THE EARTH WITH THE SAME HANDS THEY ARE PUTTING IN THE DISH."

ANATOMY OF A PAINTING #1

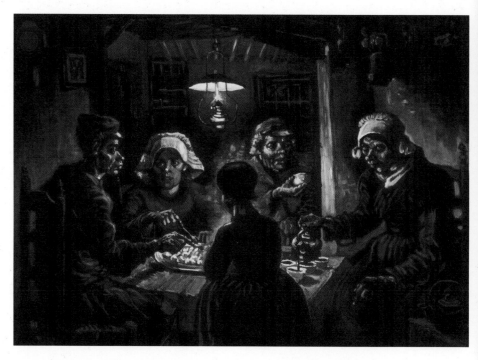

The Potato Eaters was the most ambitious of Van Gogh's early works. Rough and crude by the standards of its day, peopled by peasants who are shown in exaggerated proportions that turn them almost grotesque, it is nevertheless an ambitious work in which he intended to reveal the tough reality of life for the working poor in Brabant. He prepared for the painting assiduously, making dozens of head studies for the five figures. He worked on the final version in the De Groot family's cottage at Nuenen, outside Eindhoven, where family members had often served as his models.

▲ **The Potato Eaters**
Oil on canvas, 1885
32 x 45 inches (82 x 114 cm)

"PAINTING PEASANT LIFE IS A SERIOUS THING."

—**Van Gogh**

COIFS

The women's coifs form bright patches against the dark tones. Van Gogh was much focused on the dignity of labour when he worked on the painting and the careful, if worn, clothing reflects the values he wanted to portray.

DISH OF POTATOES

The simplest food possible, oven-cooked potatoes, eaten in the simplest way – forked straight from a communal dish. Only the coffee being poured suggests any comfort above the barest subsistence level.

OVERHEAD LAMP

An early example of the pooling of light which Van Gogh was to become so adept at painting.

HANDS WITH FORKS

The subjects' hands, like their faces, are exaggerated, with attenuated fingers and large, bony knuckles.

ROOF RAFTERS

The room space is outlined with bare rafters and a massive wooden support beam, again leaving an impression of spareness – a basic shelter.

A CHEAP MODEL

Between 1886 and 1889, Van Gogh painted 34 self-portraits in oils (plus four drawings with himself as the subject). As he said himself, he was a cheap model, and it didn't matter what he wore. The portraits give us a familiarity with the artist's face possibly only equalled in the work of Rembrandt – unsmiling, always reflective, they can make uncomfortable viewing.

We recognize the real-life props – the well-worn hats (dark grey felt and straw) and the pipe. There's the occasional extra in his situation – a Japanese print behind him, the unexpected pose at his easel – and the occasional item missing: two portraits show him bandaged up after cutting off his ear. What's striking is how different they are – even when he mentions having made two versions of the same portrait, every picture has its own qualities.

34
SELF-
PORTRAITS

2 WITHOUT EAR

5 WITH PIPE

7 WITH STRAW HAT

4 WITH FELT HAT

1 AT THE EASEL

3 WITH PALETTE

ANATOMY OF A PAINTING #2

When Van Gogh fell in love with a subject, he painted in series. His sunflowers-in-a-pot configuration exists in seven versions, each with its own atmosphere and energy, all painted in 1888 and 1889 during his time in Arles. At first glance, they look very similar, but differences become apparent the closer you look.

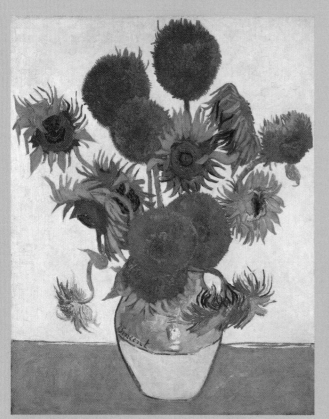

"I AM WORKING AT IT EVERY MORNING FROM SUNRISE ON, FOR THE FLOWERS FADE SO QUICKLY..."

—Van Gogh in a letter to his brother Theo, August 1888

▲ *Sunflowers*
Oil on canvas, 1888
36 x 28 inches (92 x 73 cm)

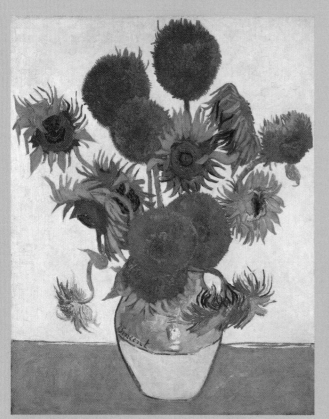

VAN GOGH

THE GROUND

Although the painting is still strikingly vivid, it's not as retina-searingly bright as it would have been when Van Gogh painted it – he used his favourite chrome yellow which browns and darkens over time.

THE POT

Of his initial four sunflower pictures, Van Gogh only signed the two with which he was most satisfied. Gauguin liked the picture so much that he asked to be given it (Van Gogh hastily painted another version to offer him – he didn't want to give this one up).

THE SUNFLOWERS

The great spreads of sunflowers in Provence offered Van Gogh his raw material.

The six flowers that are all petal, without a central seed disk, are natural mutations. The artist is more likely to have gathered them growing semi-wild in the verges than taken them from the farmer's fields. As usual, his props were cheap.

BLUE LINES

Van Gogh increasingly used hard lines to outline edges in his mature work. He attributed this to his admiration for the carefully outlined shapes found in his beloved Japanese prints.

GOGH WITH THE FLOW

In 2004, astronomers looking through the Hubble Telescope at a gas cloud were reminded of Van Gogh's painting *The Starry Night*, which he painted in an asylum in 1889 shortly after mutilating his ear. The observation prompted scientists to study the way in which Van Gogh's blending of colours created a flickering image that seemed to capture movements found in nature. They discovered the patterns in *The Starry Night* to be a sophisticated expression of the concept of 'turbulent flow' found in fluid dynamics.

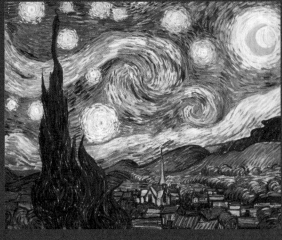

▲ **The Starry Night**
Oil on canvas, 1889
29 x 36 inches (74 x 92 cm)

Other paintings made when Van Gogh was known to be in a state of manic activity share this quality, while those made when he was in a calmer frame do not. Something in his disturbed mind seems to have matched itself to the unseen rules that govern what we see and how we see it. An image taken from space of phytoplankton in the Baltic Sea bears an even more striking resemblance to Van Gogh's extraordinary painting.

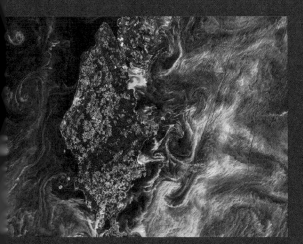

▲ Microscopic marine plants called phytoplankton create a natural impression of *The Starry Night* as they swirl on the currents around Gotland island in the Baltic Sea.

THE THEORY OF TURBULENCE WAS DEVELOPED BY ANDREI KOLMOGOROV IN THE 1940S. HE PREDICTED A RELATIONSHIP BETWEEN THE FLUCTUATIONS IN A FLOW'S SPEED AND THE RATE AT WHICH IT DISSIPATES ENERGY AS FRICTION.

SCIENTIFIC ANALYSIS OF STARRY NIGHT HAS SHOWN THAT THE PATTERNS IN THE LIGHT AND DARK SWIRLS OF THE PAINT CLOSELY MATCH THE FLUCTUATIONS PREDICTED BY KOLMOGOROV'S THEORY. IT'S AS IF THE TURBULENCE IN VAN GOGH'S MIND, EXPRESSED THROUGH HIS PAINTING, CAPTURES THE TURBULENCE EVIDENT IN NATURE.

ANATOMY OF A PAINTING #3

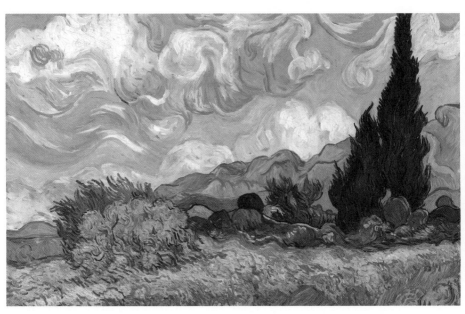

▲ *A Wheat Field, with Cypresses*
Oil on canvas, 1889
28 x 36 inches (72 x 91 cm)

As with so many of Van Gogh's paintings, this is one of three versions of the same subject – the other two are earlier and were probably painted from life. This is the third version, and the one he considered the 'finished' form of the painting. It was painted during Van Gogh's year in the asylum at Saint-Rémy. At first he worked only within the grounds, but after a month or so he went out into the surrounding countryside to paint.

Van Gogh also made a smaller version of the same composition, which he sent as a gift – a sort of postcard – to his mother and sister.

"The cypresses are always occupying my thoughts... it astonishes me that they have not yet been done as I see them."

—Letter to Theo, June 1889

CYPRESSES

Cypress trees fascinated Van Gogh – he wrote to Theo that no-one had painted them as he saw them, "that difficult bottle-green hue". They had already made frequent appearances in his paintings at Arles.

WHEAT

The wheat in the foreground is painted in thick impasto, swirled layers of paint that give it a strength and depth to the eye – and make the style instantly identifiable.

CLOUDS

The clouds, too, are painted in impasto against thinner areas of blue sky. Van Gogh used a specific canvas ordered by Theo from Paris, which arrived ready-primed, and the primer can be seen through the thinner areas of paint.

HORIZONTALS

The wavy horizontal lines of the composition are strongly emphasized, starting with the lower edge of the blown wheat in the foreground, and culminating in the energetic curls of cloud rising to the top right corner.

THE ONE(S) THAT SOLD

It isn't true that Van Gogh never sold a painting during his lifetime – he sold at least one work, and possibly more. The known sale of a painting was to Anna Boch, sister of his friend Eugène, herself a painter and a patron of other artists. Less known is the sale of a self-portrait to the London dealers Sulley & Lawrie, to whom Theo confirmed the deal in a letter dated 3 October 1888. Frustratingly, though, we don't know which portrait it was, but we do know it was an oil painting.

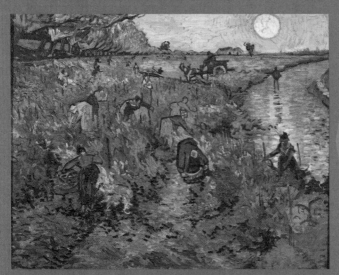

Painting:

THE RED VINEYARD

Painted:

1888

Price:

400 BELGIAN FRANCS

Current residence:
The Pushkin Museum,
Moscow, Russia

Painting:

SELF-PORTRAIT

Painted:

UNKNOWN

Price:

UNKNOWN

Current residence:

UNKNOWN

VINCENT VAN GOGH

04
LEGACY

"I CAN DO NOTHING ABOUT IT IF MY PAINTINGS DON'T SELL. THE DAY WILL COME, THOUGH, WHEN PEOPLE WILL SEE THAT THEY'RE WORTH MORE THAN THE COST OF THE PAINT..."

—Van Gogh, letter to Theo, 25 October 1888

VAN GOGH

F3.00

LEGACY

75

Cubism
(key dates 1907–1911)
Images that have an open form, with no account taken of 'correct' view or perspective, setting the scene for later abstract developments

Abstract Expressionism
(key dates 1940s–50s)
Images often non-representational, with a focus on the unconscious and its influence in art

Barbizon School
(key dates 1840–1870)
Images painted out of doors, direct from nature

DEFINING VAN GOGH

Van Gogh didn't find his place in the world while he was alive but after he was dead, and his reputation was on the rise, he was quickly offered plenty of options of where to sit at the 'High Art' table. By nature he seemed to belong to both Expressionism, alongside artists such as Edvard Munch or Georges Rouault, and among the Post-Impressionists, shoulder to shoulder with Gauguin and Cézanne. Those who would never have sought his company when he was alive were quick to claim him as their own a few years later.

Impressionism
(key dates 1867–1886)
Images that concentrated
on colour rather than minute
detail, the 'impression'
rather than a microscopically
observed whole; the techniques
of Pointillism exemplified
by Seurat

Expressionism
(key dates 1905–1925)
Images that take the
subjective view of the
artist into the finished
work, sometimes
through exaggeration

Post-Impressionism
(key dates
1880–1920)
Images that
involve an
advancement of
the techniques
and colours of
Impressionism
to take in the
artists' emotional
response
to their subjects

A GROWING REPUTATION

1928

The first *catalogue raisonné* of Van Gogh's work is undertaken by Jacob-Baart de la Faille

1930

Vincent van Gogh loans his uncle's collection to the Stedelijk Museum in Amsterdam

1962

The collection is transferred to the new Vincent van Gogh Foundation. Plans begin for a dedicated Van Gogh Museum

1925

Jo Bonger dies and the art collection passes to her and Theo's son, Vincent Willem van Gogh

1914

Jo Bonger publishes the first edition of Vincent's letters to Theo. She has Theo's body moved to a grave next to Vincent's at Auvers-sur-Oise. She commissions plain matching tombstones: 'Ici Repose Vincent van Gogh', 'Ici Repose Theodore van Gogh'

1890

Emile Bernard publishes a short posthumous biography of Vincent in *Les Hommes d'Aujourd'hui* ('Men of Today')

1891

Theo van Gogh dies. Vincent's work and reputation pass to Theo's widow, Johanna van Gogh-Bonger. Jo Bonger works ceaselessly to promote Van Gogh's reputation

1973

Queen Juliana of the Netherlands opens the Van Gogh Museum in a building designed by the celebrated architect Gerrit Rietveld

1903

Museums in the Netherlands and Austria acquire their first works by Van Gogh

1901

A Van Gogh exhibition is held in Paris at the Galerie Bernheim Jeune

1893

A number of Van Gogh's letters are published in the *Mercure de France*

1895–1896

The first solo retrospective of Van Gogh's work is held in Paris at the gallery of Ambroise Vollard

LEGACY

☐ 17 PAINTINGS

**The Metropolitan Museum of Art,
New York**

Star items include:
- *Self-portrait with a Straw Hat*, 1887
- *Madame Roulin & her Baby*, 1888
- *Wheat Field with Cypresses*, 1889
- *La Berceuse*, 1889

☐ 3 PAINTINGS

**Museum of Modern Art,
New York**

Star items:
- *The Starry Night*, 1889
- *Portrait of Joseph Roulin*, 1889
- *The Olive Trees*, 1889

☐ 2 PAINTINGS

**Yale University Art Gallery,
New Haven, Connecticut**

Star item:
- *The Night Café*, 1888

☐ 2 PAINTINGS

**Armand Hammer
Museum of Art,
Los Angeles**

Star item:
- *The Sower*, 1888

☐ 5 PAINTINGS

**Philadelphia Museum of Art,
Pennsylvania**

Star item:
- One of the *Sunflowers* series, 1889

FINDING VINCENT

Not only was Van Gogh prolific, but he also painted many works in series and on the same themes. This means that his work is more evenly spread than that of most of the other great painters, and many different collections include 'star' items on similar themes.

 6 PAINTINGS

National Gallery, London

Star items include:
- *Van Gogh's Chair*, 1888
- One of the *Sunflowers* series, 1888
- *Wheat Field with Cypresses*, 1889

 5 PAINTINGS

Pushkin Museum, Moscow

Star items include:
- *The Red Vineyard*, 1888
- *Portrait of Dr Félix Rey*, 1889

200+ PAINTINGS
500+ DRAWINGS

Van Gogh Museum, Amsterdam

Star items include:
- *The Potato Eaters*, 1885
- *Self-portrait with Grey Felt Hat*, 1887
- *The Yellow House*, 1888
- *The Bedroom in Arles*, 1888
- One of the *Sunflowers* series, 1889
- *Wheatfield with Crows*, 1890
- *Irises*, 1890

 25 PAINTINGS

Musée d'Orsay, Paris

Star items include:
- *Dance Hall at Arles*, 1888
- *The Starry Night*, 1888
- *L'Arlésienne*, 1888
- *The Bedroom at Arles*, 1889
- *Self-Portrait*, 1889 (one of the most iconic late works)
- *The Church at Auvers*, 1889

 80 PAINTINGS

**Kröller-Müller Museum,
De Hoge Veluwe National Park,
The Netherlands**

Star items include:
- *Lane of Poplars at Sunset*, 1884
- *Head of a Woman Wearing a White Cap*, 1884–5
- *The Bridge at Langlois*, 1888
- *L'Arlésienne (Portrait of Madame Ginoux)*, 1890

BRAND VAN GOGH

Van Gogh moved into global brand territory a long time ago. You can find *Bedroom at Arles* or *Sunflowers* pictured on all the usual suspects, from fridge magnets to tote bags, but both the artist and his works can be found in some unexpected places.

Visitors to Minnesota could find a reproduction of his painting *Olive Trees* created entirely with plants on a 1.2-acre (0.5-hectare) site, by the artist Stan Heard, completed in spring 2016.

If you want to walk in the footsteps of Van Gogh, a UK company manufactures a range of 'distressed' Van Gogh laminate finishes, just like those in *The Night Café* or *Bedroom in Arles* (but with a wipe-clean surface).

More conventionally, take a walking tour of 10 key sites in Arles. Although the Yellow House was bombed during the Second World War, the café terrace, the hospital and Langlois Bridge are astoundingly recognizable from Van Gogh's day.

Smoke like a genius. An Italian pipe-maker in Pesaro manufactures a range of pipes in tribute to Van Gogh.

05

There is a Van Gogh-themed restaurant in Hong Kong. Puzzlingly, the cuisine is Italian, but the surroundings are pure Van Gogh.

06

One Dutch company markets a range of Van Gogh oil paints. A characteristically lugubrious portrait looks out from its tubes.

07

As part of a major Van Gogh exhibit in 2016, the Art Institute of Chicago recreated Van Gogh's bedroom in the Yellow House, sited in a building in the city's River North neighbourhood. Guests interested in staying there could find it listed on Airbnb at the modest cost of $10 a night.

08

Absinthe lovers can find Van Gogh's portrait honouring one brand. Whatever its other qualities, its alcohol content is an authentic 70 per cent.

STEALING VAN GOGH

In the grand scheme of well-known art, Van Gogh's paintings have been stolen comparatively frequently, but he still doesn't come close to an entry in the top 10, which includes some less well-known artists whose works have been stolen in huge numbers in one-off, opportunist heists.

10 MOST STOLEN ARTISTS

Artists with the most works stolen (from Art Loss Register, 2012)

ARTIST	WORKS STOLEN
Pablo Picasso	1,147
Nick Lawrence	557
Mark Chagall	516
Karel Appel	505
Salvador Dalí	505
Joan Miró	478
David Levine	343
Andy Warhol	343
Rembrandt	337
Peter Reinicke	336

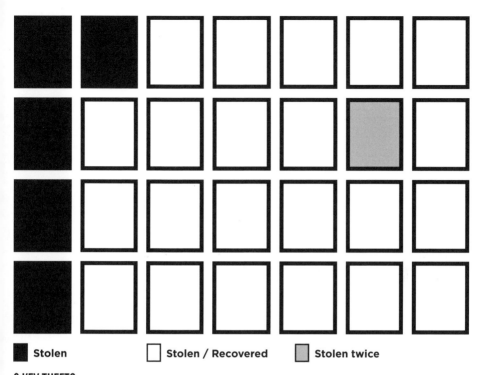

■ Stolen **☐ Stolen / Recovered** **■ Stolen twice**

6 KEY THEFTS

28 June 1990, Noordbrabants Museum, Den Bosch, The Netherlands
• *Water Mill at Gennep*, 1884
• *Peasant Woman Digging*, 1885
• *Peasant Woman, Seated*, 1885
Peasant Woman Digging was found in a bank safe in Belgium in 1992. The other two works remain missing.

14 April 1991, Van Gogh Museum, Amsterdam, The Netherlands
20 paintings stolen, including:
• *The Potato Eaters*, 1885
• *Still Life with Bible*, 1885
• *Sunflowers*, 1889
• *Still Life with Irises*, 1890
• *Wheatfield with Crows*, 1890
All the paintings were found, some damaged, in an abandoned car a few hours after the theft.

7 December 2002, Van Gogh Museum, Amsterdam, The Netherlands
• *View of the Sea at Scheveningen*, 1882

• *Congregation Leaving the Reformed Church at Nuenen*, 1884
Two suspects were arrested and convicted in 2004, but the paintings remain missing.

27 April 2003, The Whitworth Art Gallery, Manchester, United Kingdom
• *The Ramparts of Paris*, 1887
Recovered eight days later outside a public lavatory near the gallery.

11 February 2008, E. G. Buhrle Collection, Zurich, Switzerland
• *Blossoming Chestnut Branches*, 1890
Recovered nine days after the theft from a car in Zurich.

21 August 2010, Mahmoud Khalil Museum, Cairo, Egypt
• *Poppy Flowers*, 1886
Cut from its frame. Incredibly, the painting was stolen from the same museum in 1978, but was recovered two years later. To date, it remains missing.

VAN GOGH MUSEUM

Opened in 1973, the Van Gogh Museum in Amsterdam contains the greatest collection of all things Van Gogh. The original collection was Vincent's own, carefully preserved by Johanna Bonger, his brother's widow, and ultimately put on public show. It has four floors in the original Gerrit Rietveld building and an annexe for temporary exhibitions, designed by the Japanese architect Kisho Kurokawa.

NETHERLANDS

AMSTERDAM

**The Van Gogh Museum
Museumplein 6, Amsterdam**

Van
Gogh
Museum

Amsterdam

VINCENT'S WORK

200 paintings

9 self-portraits

Over **700** letters

Over **500** drawings

OTHER ARTISTS

Hundreds of examples of the work of Van Gogh's friends and contemporaries, and of the artists who influenced him, including work by Seurat (pictured), Emile Bernard, Monet, Manet and Pissarro.

PRINTS

Over 500 Japanese prints and around 1,800 French prints, including works by all the major *fin de siècle* artists and printmakers, including Toulouse-Lautrec, Paul Gauguin and Pierre Bonnard.

A separate library houses over

35,000 books and periodicals

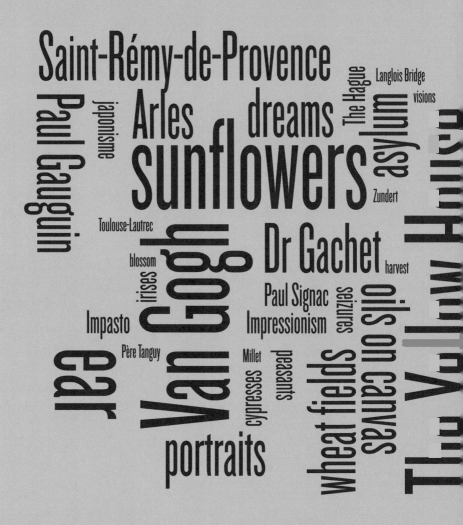

Saint-Rémy-de-Provence
Paul Gauguin
japonisme
Arles
dreams
The Hague
Langlois Bridge
visions
asylum
sunflowers
Zundert
Toulouse-Lautrec
Van Gogh
Dr Gachet
harvest
blossom
irises
Paul Signac
Impressionism
seizures
oils on canvas
Impasto
Père Tanguy
Millet
peasants
ear
Van Gogh
cypresses
wheat fields
The Yellow House
portraits

The Night Café

estant sorrow Theo straw hat

poverty prostitutes Goupil & Cie still life conflict

mania pipe

Brabant

Vincent

night sky

charcoal

watercolour

London absinthe Pointillism Paris

Sien Hoornik The Starry Night

The Road to Tarascon Expressionism

THE ARTIST ON FILM

The drama and tragedy of Van Gogh's life have inevitably proved irresistible for film directors. As early as 1947, French director Alain Resnais had taken him as a subject, and subsequent offerings range from lively to dire, from thoughtful biography to jaw-dropping melodrama, and even a full-length animation. These seven made it into cinemas – many, many others have been consigned to straight-to-TV.

 Van Gogh
1948, Alain Resnais
Respectful short biography of Van Gogh, with a solemn, rather sonorous voiceover and music.

 1950 Oscar for Best Short Subject

 Vincent: The Life and Death of Vincent van Gogh
1987, Paul Cox

Biographical documentary which concentrates on the life over and beyond the art.

 Vincent and Theo
1990, Robert Altman

Painstakingly researched, concentrating on the relationship between the two brothers.

 Van Gogh
1991, Maurice Pialat

A melodrama-free look at Van Gogh's last two months, concentrating on his extraordinary productivity and the friendship with Dr Gachet and his family.

 1992 César for Best Actor for Jacques Dutronc

Documentary

Drama

DID YOU KNOW?

Martin Scorsese played Vincent van Gogh in a 1990 surreal short film by Akira Kurosawa based on his dreams.

02 Lust for Life
1956, Vincente Minnelli
Kirk Douglas (Van Gogh, right) and Antony Quinn (Gauguin) duke it out as a pair of artistic prodigies in the film adaptation of Irving Stone's novel. Douglas wins over Quinn in the depiction of tortured genius.

1956 Oscar, Best Actor in a supporting role, Antony Quinn

06 The Eyes of Van Gogh
2005, Alexander Barnett

Psychodrama concentrating very much on the mad-artist stereotype. With Alexander Barnett as the artist.

07 Loving Vincent
2016, Dorota Kobiela & Hugh Welchman

Full-length animation, showing Van Gogh's life through the words of his letters and painstaking hand-drawn animations of his paintings. The only Van Gogh film to have been funded through a Kickstarter campaign.

UNDER THE HAMMER

When Will You Marry?
Paul Gauguin
1892, sold 2015

The Card Players
Paul Cézanne
1892/3, sold 2011

No.6 (Violet, Green and Red)
Mark Rothko
1951, sold 2014

Les Femmes d'Alger (Version O)
Pablo Picasso
1955, sold 2015

Nu Couché
Amedeo Modigliani
1917/18, sold 2015

1948
Jackson Pollock
1948, sold 2006

Woman III
Willem de Kooning
1953, sold 2006

Le Rêve
Pablo Picasso
1932, sold 2013

Portrait of Adele Bloch-Bauer I
Gustav Klimt
1907, sold 2006

Dr Paul Gachet ▼
Vincent van Gogh
1890, sold 1990

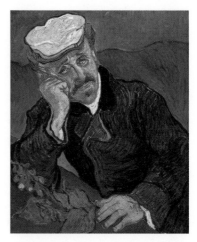

VAN GOGH

Major works from his mature period don't come up for sale very often, but Van Gogh would be astounded at how his totals stack up today. Of the nine works from his mature period that have been sold since 2005, three went for over $40 million dollars. And although he just sneaks in at number 10 in the list of the most expensive paintings ever sold, his work performs more consistently than that of many others at auction – reliable in a way he never was in life.

$300m

$274m

$186m

$179.3m

$170.4m

$165.4m

$162.5m

$158.5m

$158.4m

$152m

Prices adjusted for inflation and correct as of February 2015

Top 3 Van Gogh sale values after Dr Paul Gachet:

1 *Les Alyscamps*
 $66.3m (date of sale 2015)
2 *Still Life: Red Poppies and Daisies*
 $61.8m (date of sale 2014)
3 *L'Arlésienne*
 $40.3m (date of sale 2006)

BIOGRAPHIES

Johanna Gezina Bonger (1862–1925)
Van Gogh's sister-in-law. He met her only twice, but after Theo's death in 1881 she did everything possible to further Vincent's posthumous reputation as an artist, and by the time of her own death had had considerable success.

Emile Bernard (1868–1941)
Post-Impressionist artist and member of Van Gogh's circle: he was also friendly with Gauguin. Fifteen years Vincent's junior, the two sometimes worked together, and Bernard's innovative style is known to have impressed the older artist.

Anton Mauve (1838–1888)
Dutch painter, member of the traditionalist Hague School and a cousin of Van Gogh on his mother's side. Van Gogh worked briefly in his studio in Paris. Ultimately the two fell out, but Van Gogh was fond enough of him to dedicate a painting to him on Mauve's death.

Sien Hoornik (1850–1904)
Seamstress and prostitute who modelled for Van Gogh and lived with him in the Hague in 1882-3. Although he declared his intention of marrying her they split in the face of his family's disapproval, when he realized he had no way to provide for her and her two children.

Theo van Gogh (1857–1891)
Van Gogh's younger brother, an art dealer, who supported him both emotionally and financially for much of his life. As adults, the two corresponded every few days. Already ill at the time of Vincent's death, he died himself just a year later.

Theodorus van Gogh (1822–1885)
Protestant minister in the Dutch Reformed Church, and Vincent and Theo's father. Sensible and modest, he found his oldest son's temperament difficult, although it was 'Dorus who encouraged Vincent to try art when his earlier career attempts failed.

Dr Paul Gachet (1828–1909)

Physician who specialized in the treatment of nervous conditions. An amateur artist himself, Gachet was friendly with Courbet and Cézanne. He befriended and treated Van Gogh during the artist's difficult last months at Auvers-sur-Oise.

Paul Gauguin (1848–1903)

Innovative post-Impressionist, whose work was acclaimed only after his death. A bombastic, confident personality, he stayed for 9 weeks at the Yellow House with Van Gogh in 1888, but the two fell out and they never saw each other again.

Paul Signac (1863–1935)

French artist who worked to develop Pointillism, a style in which paintings were made of dots of pure colour. He took painting trips with Van Gogh to Asnières-sur-Seine, outside Paris, and also visited him in Arles in 1889.

Anna Carbentus van Gogh (1819–1907)

Vincent and Theo's mother, who encouraged her family's artistic leanings when they were children. She and Vincent communicated regularly all his life. Van Gogh did his best to shelter her from his less conventional behaviour.

Wilhelmina van Gogh (1862–1941)

Vincent's younger sister and, after Theo, the sibling who was closest to him. She spent some months sharing his lodgings in London in 1873 while seeking work as a governess, and the two corresponded regularly in his later life.

Vincent (Uncle Cent) van Gogh (1820–1888)

Van Gogh's father's brother and Vincent's first employer. He was a partner in Goupil & Cie, the art dealers in the Hague where Vincent worked. He acted as his sponsor later on, but Van Gogh never felt he was supportive enough.

family lover
friend

INDEX

ACKNOWLEDGMENTS

Picture credits

The publishers would like to thank the following for permission to reproduce their images in this book. Every effort has been made to acknowledge copyright holders, and the publishers apologize for any omissions.

12 Portrait 'identified as' Vincent van Gogh 'discovered' by Tom Stanford, 'championed' by Joseph Buberger, hi-res image supplied by Allen Philips / Wadsworth Atheneum Museum of Art, Hartford, Connecticut.
14 Hieronymus Bosch: Universitätsbibliothek Leipzig.
17 Charles Darwin: Everett Historical / Shutterstock.com.
37 *Postman Joseph Roulin*, 1888: Photo © copyright Everett – Art / Shutterstock.com.
43 *The Night Café*, 1888: Photo © copyright Yale University Art Gallery.
44 *The Yellow House (The Street)*, 1888: Photo © copyright The Artchives / Alamy Stock Photo.
60 *The Potato Eaters*, 1885: Photo © copyright Everett – Art / Shutterstock.com.
64 *Sunflowers*, 1888: Photo © copyright Everett – Art / Shutterstock.com.
66 *The Starry Night*, 1889: Photo © copyright Everett – Art / Shutterstock.com.
66 Microscopic marine plants: Courtesy NASA Goddard Photo and Video Photostream, USGS/NASA/Landsat 7.
68 *A Wheat Field, with Cypresses*: Photo © copyright World History Archive / Alamy Stock Photo.
70 *The Red Vineyard*, 1888: Photo © copyright Heritage Image Partnership Ltd / Alamy Stock Photo.
90 *Dr Paul Gachet*, 1890: Photo © copyright Everett – Art / Shutterstock.com.

AMMONITE
PRESS

To place an order or request a catalogue, please contact:
Ammonite Press
GMC Publications Ltd, Castle Place, 166 High Street, Lewes, East Sussex, BN7 1XU, United Kingdom
Tel: +44 (0)1273 488006
www.ammonitepress.com